W9-BLN-602

CONTENTS

Walter Foster Publishing, Inc.
430 West Sixth Street, Tustin, CA 92680-9990

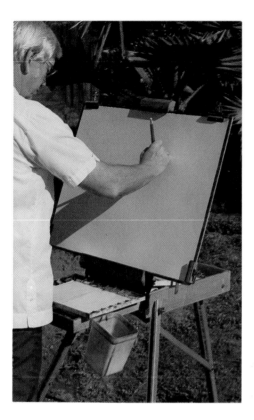

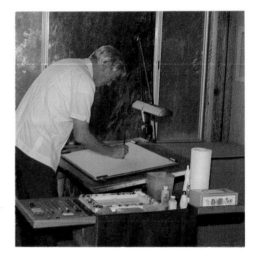

The French easel is my choice for painting on location. I also use it for working in the studio, teaching, and demonstrations. I prefer to stand when I work, especially when drawing, as this gives me freedom to step back and analyze the whole surface often. What is happening on the whole surface of the paper, drawing or painting, is *the* most important of all. Standing is optional, as there are many types of easels for both standing and sitting. However, it is important to sketch at arms length, using the arm and body to get feel and geometry in our drawing, and not too much detail in the beginning. Character is more important than detail. Detail can be added during completion of a painting. I always finish a painting in a vertical position so I can get back to a good viewing distance of 8 to 10 feet and decide what, if anything, it needs in the final touches. I put a trial mat on and examine it carefully before framing.

In the studio I have a drawing table with a surface tilted at approximately 15° as you see here. I have north light on the left and cool flourescent above the board for dark days or night work, including a ceiling fixture with two large tubes overhead. On my right, being right handed, I have a taboret with rollers on which I keep brushes, paint, water and such things as sponges, salt, masking material, towels, etc.

I have a vertical easel behind me which allows me to take the painting off the table and put it on the easel for working both horizontal and vertical and for viewing. Some things in watercolor can be handled better vertical, some better horizontal. This will come with experience. Don't be afraid to experiment. The joy of discovery is an important part of art and makes watercolor the exciting media it is.

PENCILS

I recommend an HB Drawing Pencil. They work well for sketching directly on watercolor paper. They do not leave too much graphite and they do not engrave into the paper.

ERASERS

A kneaded rubber eraser actually picks up graphite. It does not smear it around or into the paper. Kneading it between your fingers will keep it usable. When black, discard. Erasers that are for pencil and/or ink are valuable in drawing and painting.

SKETCH PAD

I keep an 11×14 sketch pad in my van at all times and sketch every day. We learn to see by sketching constantly. This also increases your painting vocabulary like a writer constantly reading. It keeps reference material readily available.

PAPER

Here there is no substitute for quality. I recommend the finest watercolor paper, made in France or Italy. 140 lb. rough is an ideal paper to begin with, many professionals use it consistantly. It comes in standard 22×30 sheets and can be cut to any size. You can use both sides if you make an error.

BOARD

An ideal board to begin with is 18″×24″. This will accommodate a ½ sheet well. For an 18″×24″ sheet, I recommend a 20″×26″ board. Several boards can be cut from a sheet of ⅜″ plywood. Sand edges. Commercial boards are also available.

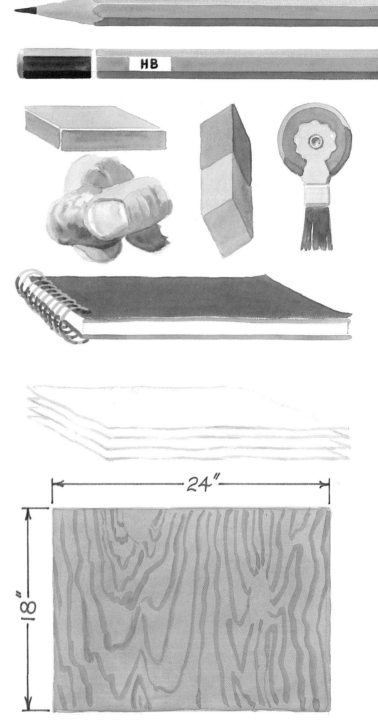

3

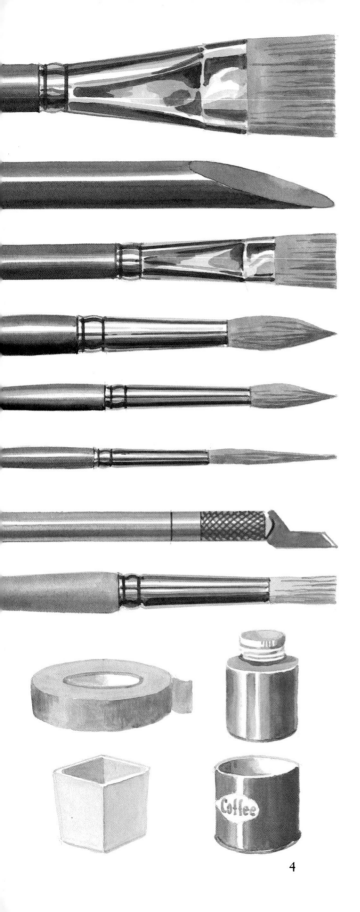

BRUSHES

Buy the best brushes you can afford. Red sable is the ideal but many of the new man-made fibers are acceptable. The 1″ flat brush will be your workhorse. Select it carefully. It should be sharp and straight edged when wet. The better brushes have a handle formed as shown here for various uses in painting.

A ½″ flat brush will give you more control in smaller areas and when cutting around whites.

Buy a good #12 or #14 round. They should point well when wet. Experiment to determine what you do best with round or flat brushes.

For detail a #6 or #7 will accomplish everything you need. Select one that has a good point. Sable is the best.

A rigger is a brush with longer bristles than the other brushes allowing for more freedom and a more casual look when lining.

A hobby knife has many uses in painting and around the studio.

A stencil brush can be useful for scrubbing out small areas to reclaim whites.

MASKING MATERIAL

Drafting tape can be used for masking off certain areas. Masking fluids of a rubber cement type material can be painted on and removed after painting is completed to preserve the whites. Experiment first as these will remove the surface of lesser grade papers.

WATER CONTAINER

Plastic refrigerator containers work well if they are sturdy and hold a quart of water easily. A 3 lb. coffee can will work just as well.

TRANSPARENT WATERCOLOR

Colors come in several different size tubes and qualities. The student paints work well. The professional colors are used for their consistency and permanency. Color is an individual thing and here is a list for your consideration. You will want to drop some and add some as you progress in your career. As many as 84 are offered by some companies. The ones marked with an asterisk are almost a must to begin with.

PALETTE

Personnal choice enters in here also. Many sizes and shapes are available although costs are very much the same. Time will tell what works best for you. I use a palette that will hold almost a tube of each color, 24 wells for a good selection and a cover for preservation as color is expensive.

PAPER TOWELS

A must around the studio. I use them often during painting to remove excessive moisture from the brush.

PAPER HANDKERCHIEFS

These also have multiple purposes around the studio and are useful in painting for lifting paint or producing texture.

NATURAL SPONGE

Some artists use several kinds of sponges for textures. I use a cosmetic sponge for wetting paper and lifting out whites, a natural sponge with larger features for texture. See page 45.

Lemon Yellow
*Cadmium Yellow Pale
 or New Gamboge
*Yellow Ochre
 Raw Sienna
 Cadmium Orange
*Vermillion
*Cadmium Red Medium
 Rose Madder (genuine)
*Alizarin Crimson
 Venetian Red
*Burnt Sienna

Burnt Umber
*Ultramarine Blue
*Thalo Blue
 Cobalt Blue
 Manganese
 or Cerulean Blue
*Thalo Green
*Paynes Gray
 Thalo Purple
 Cobalt Violet
 Ivory Black

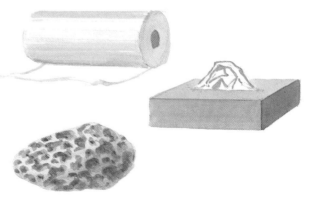

5

SANDPAPER	SALT	ALCOHOL	WATER SPRAY

Four grades will give different textures especially on rough watercolor paper. See page 45.

A table salt will give some special effects that cannot be achieved any other way. See page 44.

Any rubbing alcohol will work fine. Alcohol works best on smoother surfaces when paint is wet. See page 44.

Water in a hair spray dispenser is useful in painting to keep all or part of the paper wet while working and for texture when sprayed into a wet wash.

CLIPS

These clips can be obtained in any variety type store. Get at least four of each size. Some artists still wet the paper thoroughly and staple it to the board with ¼″ staples while it is still wet and let it stretch while drying, then work on the sheet. I still do this sometimes.

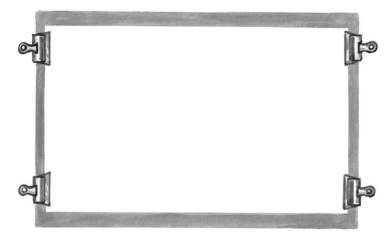

However, using the clips, we can clamp the paper on the board as shown and begin to paint on the sheet immediately. As the sheet begins to expand because of wetness, it will get wavey and begin to buckle. Simply loosen the clamps one at a time and stretch the sheet until it is flat again. Continue to do this until it stops being wavey. After painting is done it will remain flat.

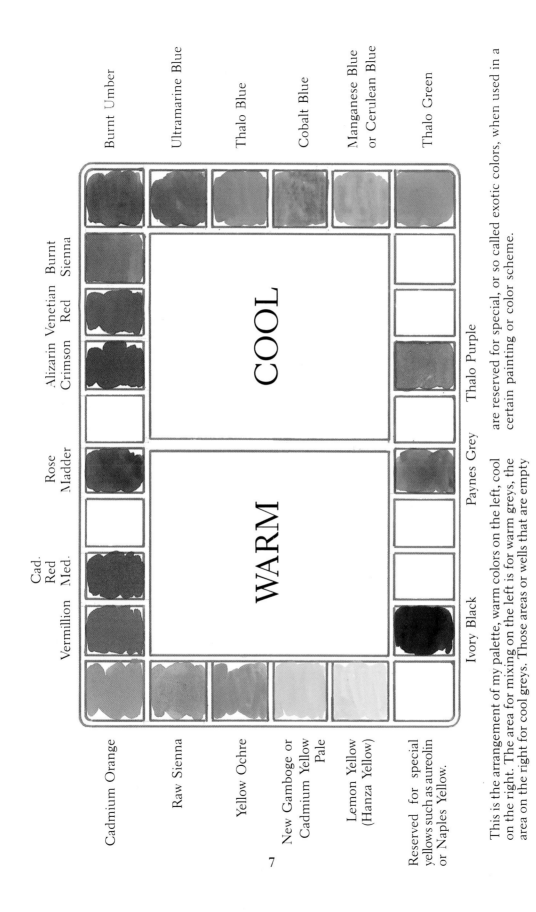

Burnt Umber

Ultramarine Blue

Thalo Blue

Cobalt Blue

Manganese Blue or Cerulean Blue

Thalo Green

Burnt Sienna

Venetian Red

Alizarin Crimson

Rose Madder

Cad. Red Med.

Vermillion

COOL

WARM

Thalo Purple

Paynes Grey

Ivory Black

Cadmium Orange

Raw Sienna

Yellow Ochre

New Gamboge or Cadmium Yellow Pale

Lemon Yellow (Hanza Yellow)

Reserved for special yellows such as aureolin or Naples Yellow.

This is the arrangement of my palette, warm colors on the left, cool on the right. The area for mixing on the left is for warm greys, the area on the right for cool greys. Those areas or wells that are empty are reserved for special, or so called exotic colors, when used in a certain painting or color scheme.

7

INTRODUCTION

Seeing is the miracle by which we become acquainted with the infinite beauty that surrounds us. Learning to see—to look— lines we make shapes to analyze, compare, and to evaluate. The arrangement of shapes, the relationships of one to another

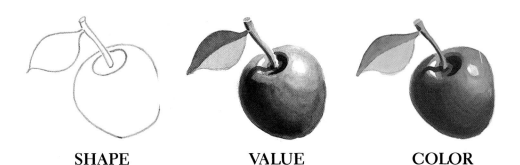

SHAPE **VALUE** **COLOR**

to appreciate this world of vision and to understand what we see is the basis and reason for art.

As artists, we have an obligation to our fellow man to observe the world with a "practised" eye and present it to him in such a way that he says "I never saw that before" and cause him to go looking at a more wondrous world, to take time to "smell the roses".

To do this, there are four things which are as necessary to the artist as to all other endeavor. These four things are...Desire, Determination, Discipline and Direction.

We hope this book will encourage you in the first three and provide you with the fourth.

To communicate we must understand something about what we see. What we see is SHAPE, VALUE and COLOR. With is the artists decision. This will determine if a surface is pleasing, attractive, aesthetically appealing, exciting, serene, etc. Value, the area between white and black, the contrast of lights and darks, gives shape and distance to our world. Color is the bonus, the added attraction, the extra sense that few creatures enjoy. Color is that extra dimension, in conjunction with shape and value, that gives the artist unlimited means of expression. If we think of art as something to be seen, felt, experienced and understood, we must have the elements to accomplish this. They are LINE, SHAPE, VALUE, COLOR, TEXTURE, SIZE and DIRECTION. PRACTICE is important. Draw and paint consistently. Don't be afraid to make mistakes. If you are not making mistakes or are not confused, you are not learning. TRY—GROW—PLAN TO SUCCEED!

THE BUILDING BLOCKS OF ART

We will consider each of these as we progress, and in the order they occur here. In ART certain facts apply and cannot be changed. How well you understand and perform in each of these areas is important. The media, watercolor, oil, acrylic, pastel, etc. are a matter of choice. What you produce with them is a matter of study, research and PRACTICE. Art can be learned.

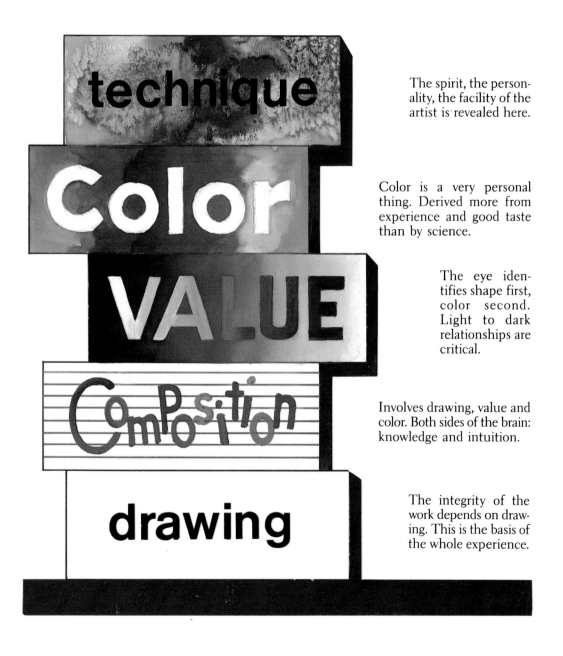

The spirit, the personality, the facility of the artist is revealed here.

Color is a very personal thing. Derived more from experience and good taste than by science.

The eye identifies shape first, color second. Light to dark relationships are critical.

Involves drawing, value and color. Both sides of the brain: knowledge and intuition.

The integrity of the work depends on drawing. This is the basis of the whole experience.

DRAWING

SKETCH! Don't be afraid or worried about extra lines. Sketch freely, lightly; extra lines can be removed with erasers. These are called finding lines. In sketching, we search for the truth...shapes, relationships and arrangement that please the eye. A few rigid diagrams, basic to perspective are shown here. Once ingrained in the mind, we need not carry them to a conclusion every time but we can be confident we are right. Look for relationships. Be observant. Be selective. LEARN TO DRAW BY DRAWING.

In your sketch book or some place where you can refer to it easily, draw a vertical line and a horizontal line as shown. The horizontal is *eye level,* the vertical is the edge closest to you. Put a dot at each end of the horizontal and mark them VP for vanishing point.

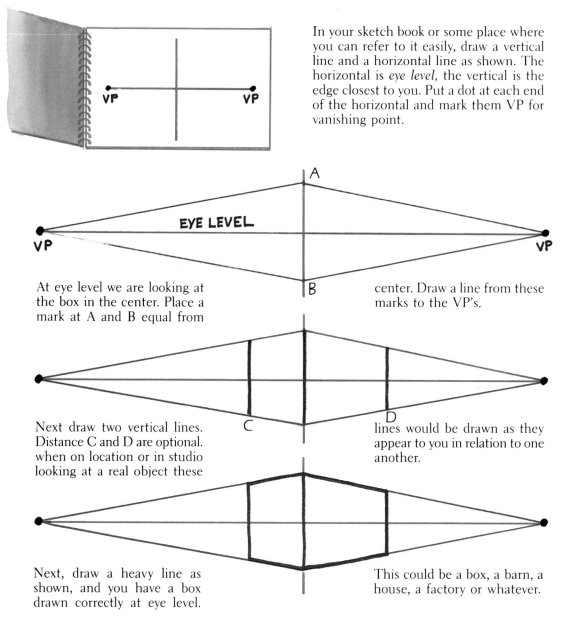

At eye level we are looking at the box in the center. Place a mark at A and B equal from center. Draw a line from these marks to the VP's.

Next draw two vertical lines. Distance C and D are optional. when on location or in studio looking at a real object these lines would be drawn as they appear to you in relation to one another.

Next, draw a heavy line as shown, and you have a box drawn correctly at eye level. This could be a box, a barn, a house, a factory or whatever.

Now repeat the last drawing and extend the vertical center line top and bottom. Mark the distance A and B above and below. The height of the object does not change as we raise or lower it. Extend lines from A and B to VP's. Next we extend vertical line on the left and

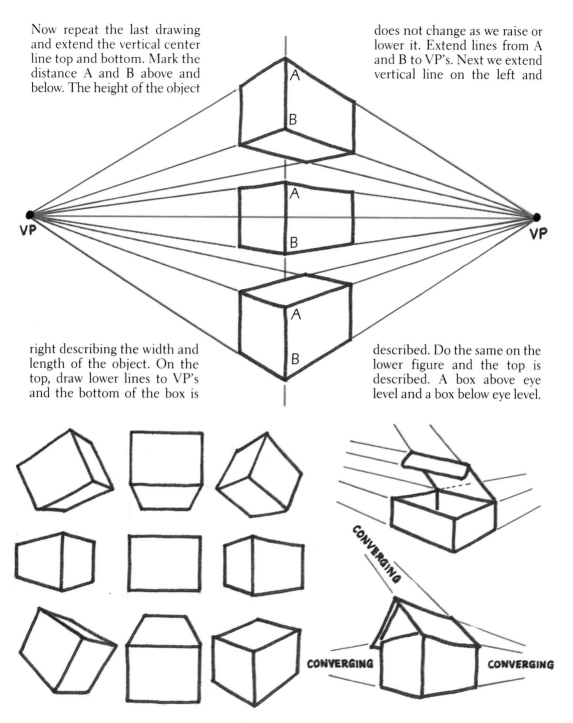

right describing the width and length of the object. On the top, draw lower lines to VP's and the bottom of the box is described. Do the same on the lower figure and the top is described. A box above eye level and a box below eye level.

CONVERGING

CONVERGING

CONVERGING

Practice drawing a box or cube at all angles. When you are confident you can draw a box at any attitude in space and it appears correct, you have accomplished an important step in drawing. Almost anything will fit into a box including people. This is the simplest of the geometric forms and the best place to begin.

Notice the simple forms on the right. Converging lines are a good way to check your drawing. Use actual lines if necessary but you will get used to looking for these in you mind's eye.

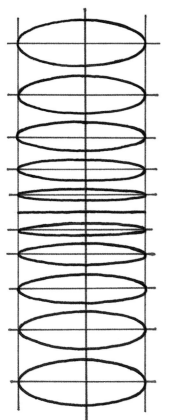

CYLINDER

Practice drawing the ellipse. Draw a vertical center line. Draw a line crossing this for eye level. Now above and below eye level, begin throwing ellipses freehand; first narrow, then wider and wider as they stretch above and below eye level. At the ceiling and the floor, they would be a circle. Now select an ellipse below eye level and draw the top of your can. Draw the vertical outside lines and then draw an ellipse for the bottom. The bottom ellipse will be wider than the top one. The opposite is true when a cylinder is above eye level.

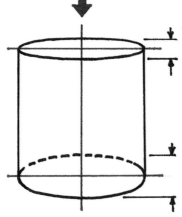

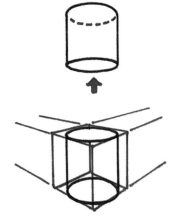

Notice: the cylinder fits in a box if it is correct.

Practice drawing cylinders at various angles. Draw the center line first. If the top is flat and level, the ellipses will always

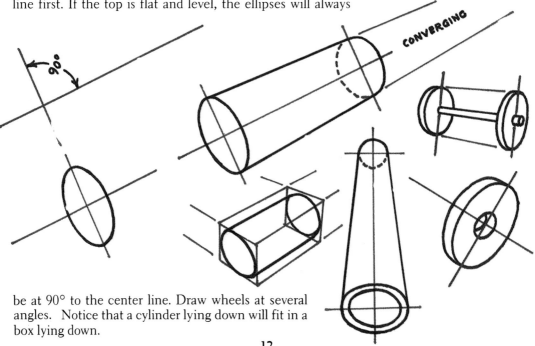

CONVERGING

90°

be at 90° to the center line. Draw wheels at several angles. Notice that a cylinder lying down will fit in a box lying down.

12

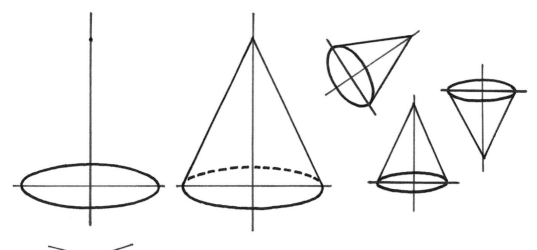

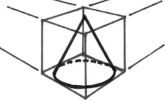

CONE

Draw a vertical center line and a line crossing it at the base or floor line. Sketch an ellipse at the bottom. Connect the extremities of the ellipse with an arbitrary point at the top. Practice drawing the cone at various attitudes. The cone will fit in a box if drawn correctly.

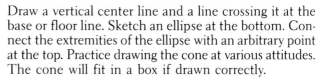

SPHERE

To draw a ball is quite simple and a little practice will give us a good one. However, the ball has depth or three dimensions as shown here in the box. This must be taken into consideration when drawing it with other objects.

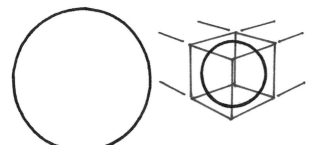

Combinations of two or more of these shapes can be found everywhere. Spend some time sketching inside and outside. Look carefully at shapes, proportions and relationships. Evaluate your drawing. Set up your sketch. Stand back and look. Are you satisfied? Paint will not make a bad drawing look good. Good sketches are rewarding. They are future studio paintings.

13

COMPOSITION

FIRST, choose a format. What SIZE, what SHAPE, will serve best for your presentation...a square, a vertical, a horizontal. Sometimes the subject dictates shape but it is still your decision. Not only are arrangement (drawing), value and color involved in composition, but principles such as unity, dominance, conflict, repetition, balance, alternation, harmony and gradation must be considered. Volumes have been written on composition. Read what is available to you. Better yet, study great paintings. These pages are not rules but are offered as things to be considered during the planning and entire production of a painting.

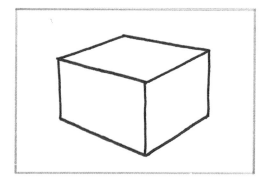

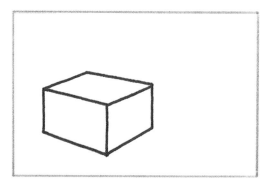

 The relationship between Positive (subject) and Negative (background) space is important. Here they are equal.

 When one is greater than the other, both should be interesting. Positioning is important.

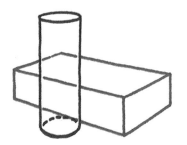

Sketch a box and a cylinder. Learn to draw them in a given space. Position them so positive and negative space are equally interesting. Move the objects around to get different shapes. Check the relationships of one subject to another and the relationship of the combined shapes to the total surface.

Drawing these objects together is one thing. Placing them in a pleasing arrangement on a chosen format is another. SKETCH until you are satisfied with *both*.

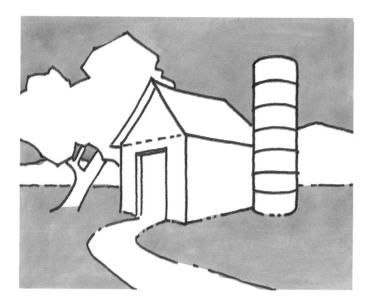

There are two kinds of drawing. Investigative—getting acquainted with the subject. Compositional—putting everything together. SKETCH these objects until you are happy with them. Not too formal or stiff. Character is more important than accuracy or detail. Draw them together in a rectangle as shown. Do they look like they are all on the same surface? If you cut the negative space out of black paper, would it be interesting too?

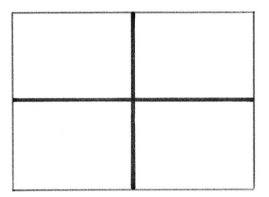

SPACE DIVISION

It's a good idea to analyze our sketch before finishing it into a drawing or painting to see if it divides the space in half either vertically or horizontally. Best not to have roads, rivers, or any of our design going in or out of the paper at these points.

A horizon line like this divides the paper in half. The equal space of sky and water sets up a sort of competition already. Moving the horizon up or down makes the contrast between these areas more exciting and we begin our design with a plus instead of a minus.

Dividing the space with a light line into thirds vertically and horizontally can sometimes help in placing things in a more interesting or exciting arrangement. Step back and see if the whole surface is appealing to you as you sketch.

FORMAL BALANCE

This is not wrong, but has a chance of monotony and boredom. Value, color and texture must also be considered. Try another approach before a final decision.

INFORMAL BALANCE

More visually exciting. Unequal space and changes in size are easier to live with if they still balance.

SUBJECT PLACEMENT
(key positions)

For years, this has been the method for location of the ideal position on a piece of paper or canvas for the esthetically correct placement of subject. Like most rules, many of the great artists have moved these positions in and out.

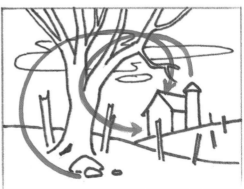

Consider them when sketching your subjects. View your sketch in a vertical position. Would it have been better to use one of these locations?

MOVEMENT

Is your eye kept within the picture? Examine your sketch, do you lead the eye around the surface? Are things related the best way? Take time to analyze *before* you paint.

IMPLOSION

It's best not to have things flying out of the painting but working *in*. The viewer should be drawn into the painting like reading a mystery novel, they just can't escape until they find out "who done it." This is accomplished by arrangement, detail, value, color or texture. Think about it before starting the painting.

ATTENTION BY CONTRAST

An area of each painting, possibly one of the four areas discussed on page 17, should have greater contrast (light against dark) than the rest. The eye goes first to those areas of highest contrast, hardest edges, then around the painting. This is the "hook", you have attention here, show off, right here should be your best shot.

OVERLAP

Whenever things just touch each other or the border, the mind is not sure of the message. What's up front, what's in back? *Solve* this problem for the eye. Place shapes relative to one another by overlap, fully in the painting or extending beyond.

VERTICAL, formal or informal, is stately, soaring, dignified.

HORIZONTAL, predominate in landscape, is restful, quiet.

CURVALINEAR can be slowed down with vertical or horizontal movement.

FRAME IN FRAME.[*] Captured subject and viewer. Many paintings intentionally or unintentionally fall into this configuration. Good solid composition. It lets you in and keeps your interest inside.

CRUCIFORM. Not new and somewhat difficult. A good idea to bring viewer into the painting if handled well in execution. Exciting challenge for the painter.

FALLING LEAF. A nice, happy leisure feeling. Interrupted by vertical or diagonal movement it can be slowed down and made more interesting.

[*] "(Courtesy of Rex Brandt)"

DOMINATE THEME. A dominate theme should be obvious but interrupted by some sort of conflict it will be more interesting. Diagonals are active, restless, disturbing...Can be used with any of the above. Be cautious of dominate diagonals.

SCALE

The eye delights in different sizes and shapes. From large boulders to sand, the mind seems to enjoy running up and down the scale like in music.

SIZE AND NUMBER

Three, five, seven, etc. seem to be more interesting. Variation in size and uneven numbers are something to consider in each composition.

PAINTING

Nothing is as important to success as practice! Don't hurry and don't worry. When relaxed you can feel things happening right!

Clamp a half sheet of paper to the board. Divide it into four rectangles 6″ ×9″ as shown, with a pencil. Beginning in the upper left we will practice some washes with different brushes. Start with a flat 1″ brush. Do all of these washes with Burnt Umber. Put some out in the center of your palette with the brush and dissolve it with water until it is a wash. Try it on a piece of paper, it should run freely off the brush and produce a medium value of brown like you see here.

Starting at the top and moving from right to left, overlapping each stroke like mowing a lawn, lay a flat wash on the entire area.

The board should be tilted about 15° to allow the watercolor to flow from top to bottom easily. If too light, add pigment, if too dark or thick, add water, if it doesn't cover, it is too dry. A well

charged brush should carry across once or twice readily. Repeat this with a ½″ flat brush. Always use the biggest brush that is comfortable to you.

Repeat this exercise with your largest round brush. Getting acquainted with what a brush can do is critical. Practice different strokes with each brush you own. Know what it will do for you.

GRADED WASH

This is something that can be done better and more beautiful in water color than any other media. It may be the most distinguishing factor. Go across the top with a fully charged brush, adding only water as you proceed back and forth down the area. Practice this until you achieve a good result.

After this graded wash dries, experiment. With a ½" brush, add window panes, single stroke, top to bottom.

With a smaller round brush, add shadows determined by a light source (arrow). Practice scratching out highlights with knife (page 4) or ink eraser (page 3).

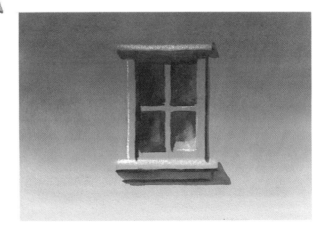

21

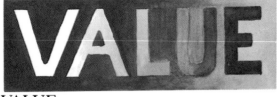

VALUE

The eye sees value first. We see light and feel dark. Everything is presented to the eye by value relationships, with little or great contrast. The steps from white to black have depicted everything on the printed page for centuries. A good way to prove your painting is to take a black and white photo of it and see how it reads.

Draw 10 rectangles on a piece of watercolor paper twice the size you see here with pencil. Now, using Burnt Umber and a ½″ brush or a large round brush, start at the top with an extremely light wash and progress down to 100% Burnt Umber directly out of the tube with just enough water to spread it. At this point, it is opaque and no longer transparent watercolor.

Step back 8' to 10' and you will hardly be able to distinguish between adjoining washes. Therefore, we want bigger steps (more contrast) between washes so we use (1) white, this is the watercolor paper; (2) 30%; (3) 60% and (4) 90%. These are the ideal steps in a watercolor painting. You may wind up with 5 or 6 but this is better than 12 or 13 which almost always produces mud.

Clip a ½ sheet to a board and with a pencil, mark off four rectangles as shown. These will be about 6″ ×9″.

SKETCH A BOX in upper left space. Check all your lines to see if they are converging as shown. Make the box large enough to paint and a little to the left to allow room for shadow. Getting used to drawing with good proportions in a limited space is important. After drawing the box, establish a light source, (upper left). Now this is about the way a shadow would appear outside at 10:00 in the morning.

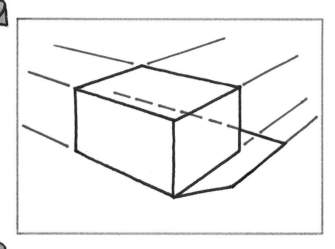

Put a box outside and experiment. If you paint in the studio, you should be able to approximate or at lease define some believable shadows in a painting. Step 1 shows light coming across the corner and establishing a point on the surface the box is on. Step 2 shows light falling across the edge of the box defining a line on the surface, vanishing at the same point as the edge that is casting it. This line ends at a point where the box ends. Step 3: then the far edge casts a shadow behind the box vanishing at the same point to the left that this edge does.

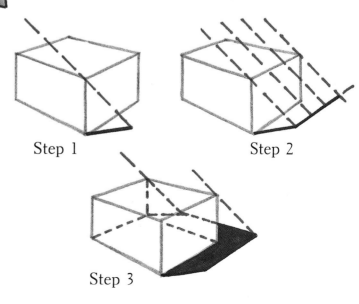

Step 1

Step 2

Step 3

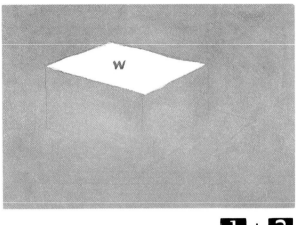

VALUE PAINTING OF A BOX

Steps 1 and 2 are accomplished at the same time. Mark a W in the area to be left white just as a reminder. Now, with a flat or round brush, lay a flat wash of 30% Burnt Umber from top to bottom, leaving the white. Let this dry. The painting is ½ completed.

 1 + **2**

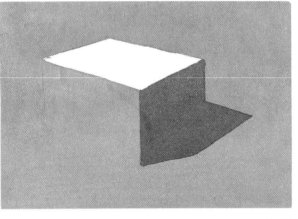

The next step is a wash of 60% over the side that is in shade (away from the light source) and the shadow. Let this dry.

3
4

Paint the shadow in 90% completing the exercise. If you did not wait long enough between steps, the watercolor will let you know. We need not teach dont's in watercolor as the watercolor will tell you what not to do.

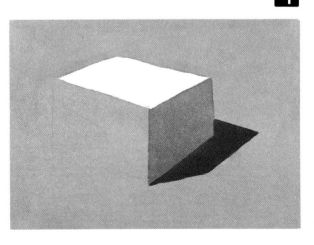

Determining exactly when you can go back into watercolor comes only with experience.

VALUE PAINTING OF CYLINDERS

SKETCH two cylinders in the next space on the sheet. First, draw the one lying down to your satisfaction. Now draw one standing in front. Be sure to allow space when drawing the bottom ellipse between the two cylinders, so they both have their own space. Next, with a light source from upper left, sketch in the shadows as shown.

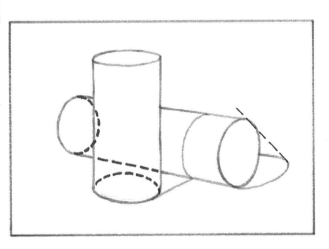

1 + 2

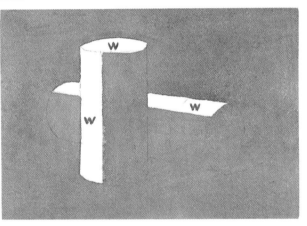

Place a W in the areas to be left white as a reminder and starting at top with the largest brush comfortable to you, lay a 30% of Burnt Umber over all of the area except the whites. Let it dry.

3

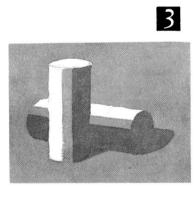

Next, lay a 60% wash over the sides away from the light as shown. Be sure to leave some of the original 30%.

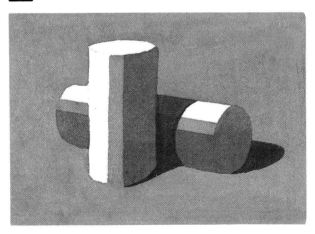

Finally, cover the area in shadow with a 90% wash. Evaluate your finished product. These principles will be a part of your knowledge.

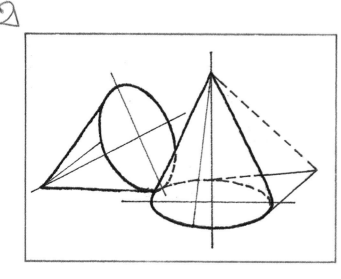

VALUE PAINTING OF CONES

Sketch 2 cones as shown. When you think they are correctly drawn and look good in the space, wash them in with Burnt Umber and try a different brush than you have been using. Be sure your pencil lines are just dark enough not to be covered by the first wash.

Start at the top with 30% value. If it will help you to remember the whites while putting on the first wash, mark them with a W as we did before. Let it dry.

When laying the 60% wash be careful not to cover all of the 30% original wash on the cones. Change brushes if you will feel more confident in these smaller areas.

Complete this exercise by painting the shadows with a 90% wash.

1 + **2**

3 **4**

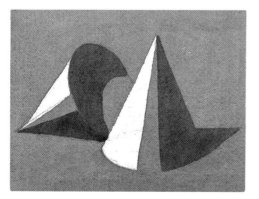

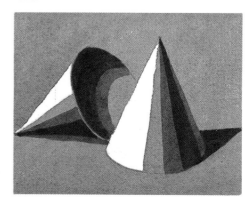

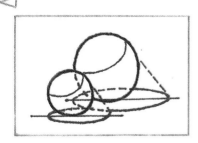

VALUE PAINTING OF A SPHERE

Sketch 2 spheres of different sizes. Overlap them as shown and describe an ellipse for the shadow of each sphere. Where they come together will make an interesting shape. More so than if they were separate.

Lay a 30% Burnt Umber wash from top to bottom. Although these are just exercises, try for perfection.

This 60% wash may be best executed with your largest round brush as it involves curves. Practice and use the brush that works the best for you.

Wash in the 90% value on the shadow areas. Don't be afraid to change brushes at any time on a painting.

1 + **2**

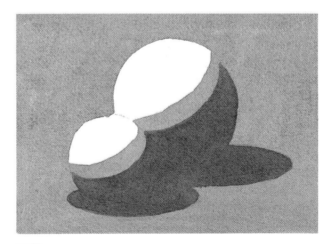

3

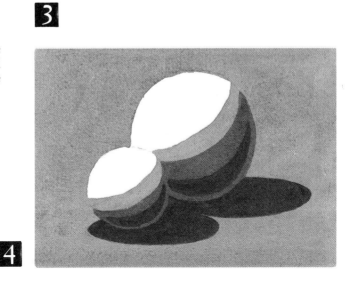

4

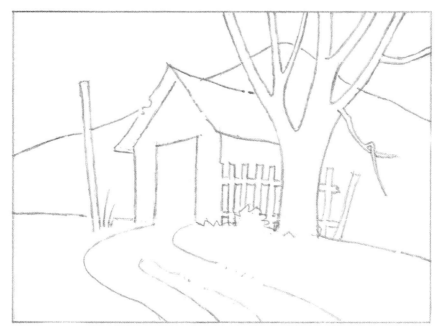

Sketch an outdoor scene on a ¼ sheet. Clamp a ½ sheet on the board and turn the board vertical. Work on the bottom half. Sketch in pencil directly on the paper.

Remove unwanted lines with kneaded rubber eraser. Leave lines just dark enough to see through subsequent washes.

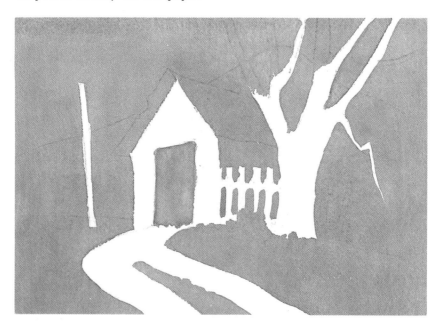

1 + **2** Save the whites! The first consideration in watercolor. They can be toned down or painted out later. Lay this 30% wash with Burnt Umber. The larger the brush, the more control you will have of the wash itself.

28

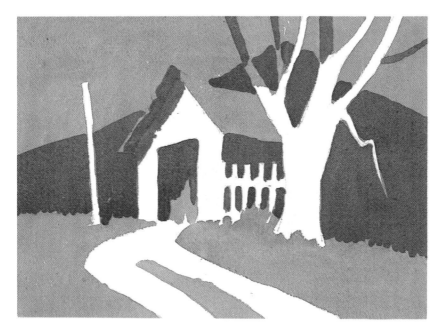

3 Apply this step, the 60% wash, after the first wash had dried. This is necessary only if you want hard or sharp edges. Experience will tell you when to go into a wash for soft or diffused effects.

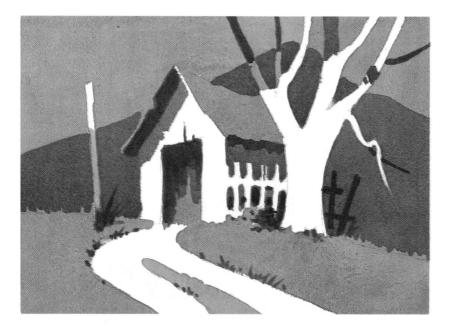

4 Washing in of the shadows with a 90% value gives us virtually a completed painting. This is the time when we must consider "how much" detail will enhance the painting. This can be easily overdone.

COLOR

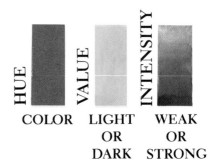

HUE	VALUE	INTENSITY
COLOR	LIGHT OR DARK	WEAK OR STRONG

Color is a personal thing. Of course, an understanding of the properties and theories of color can be helpful. That is why they are offered here. Color is a lifetime of experience and developing good taste. Color in painting is largely a right brain experience, trusting our taste and instincts, watching the paper, experimenting, responding, seeing, remembering.

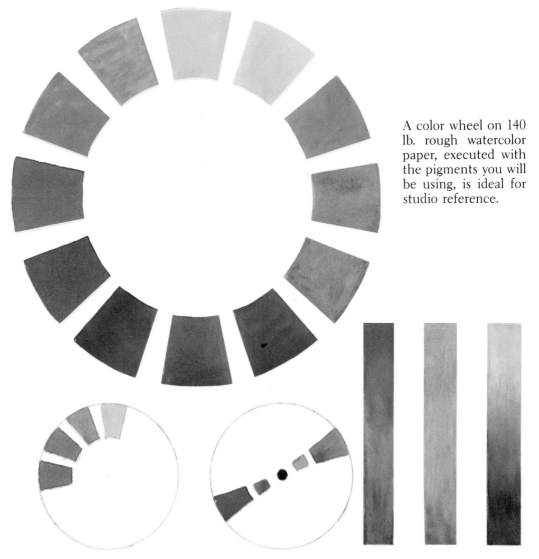

A color wheel on 140 lb. rough watercolor paper, executed with the pigments you will be using, is ideal for studio reference.

Analogous colors: colors adjacent to one another around the wheel.

Complementary colors: Directly across from one another on the wheel. Mixed together, they grey one another. Practice painting the transition between two complements.

Make a color wheel for your studio. You can buy one but they are printed in ink and not much value to a watercolorist. Make your outside circle about 9" in diameter and the inside one 6½". Use end of a ½ sheet of watercolor paper, the same kind of paper you plan to paint on. Divide these two circles into 12 spaces with ½" between each one. Start at the top with New Gamboge or Cadmium Yellow Pale. Count down 4 spaces to right and wash in Cobalt Blue. Four more spaces and wash in Cadmium Red Medium. Wash in these colors strong but not opaque. Between each of these use Thalo Green, Cobalt Violet and Cadmium Orange. These are the secondary colors. The intermediate colors are Thalo Yellow Green, a mix of yellow and Thalo Green. Blue green, a mixture of Thalo and Cobalt (Ultramarine blue may work better). Purple: Ultramarine blue with a little Alizarin Crimson. Next, Alizarin Crimson, Vermillion and Cadmium Yellow Deep or a mixture of Cadmium Orange and New Gamboge. Keep this in your studio for reference until you *know* these colors and their complements.

HIGH KEY MEDIUM KEY LOW KEY

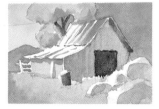

Each of these communicate a different feeling or mood. Studying the history of painting is invaluable. Unless we are willing to experiment, we will find ourselves painting everything in about the same key. Reach out! Paint the same painting in more than one key. Dare to fail. You will be rewarded.

PROGRESSION OF COLOR TOWARD A CLIMAX

It's difficult to arrest someone's attention with intense color everywhere, competing. Think in terms of (1) out of focus greys, (2) more defined areas in greyed but definable color and (3) specific areas in sharp focus and pure or rich color.

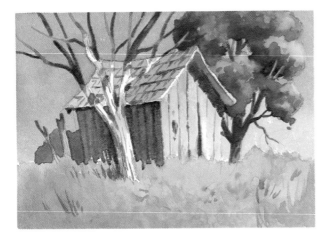

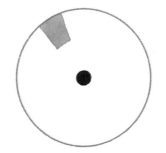

Using the color wheel to determine a color scheme, paint several ¼ sheet paintings.

MONOCHROMATIC

This is one color and black. Try several of these, they can be very rewarding.

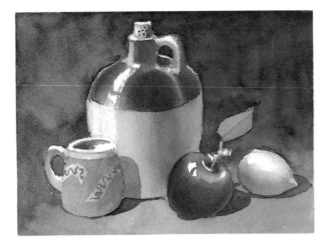

COMPLEMENTARY

Here we have a full range of greys, black, a warm and a cool color. Practice with the complementaries. The rewards are great.

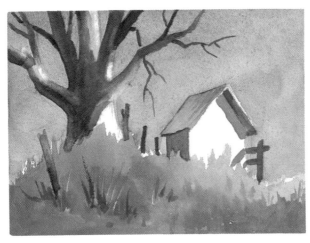

SPLIT COMPLEMENT

Cut a template to fit over your color wheel with these three holes in it. Move it around your color wheel and paint several split complement schemes.

SEMI-TRIAD

Cut these three holes in a template to fit your color wheel. Move it around. This limited palette offers many challenges.

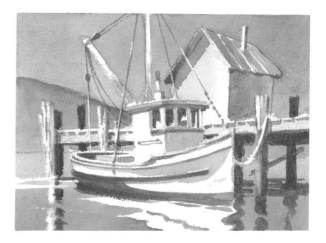

TRIAD

Using the triad *other* than the three primaries is important in your experience. The three primaries is the same as all color.

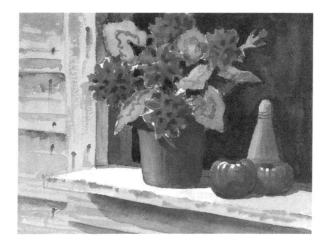

TWO COMPLEMENTS

Orange, blue, red and green seem to be favorites. Experiment with other double complements.

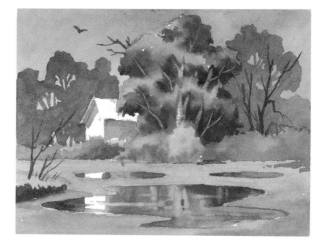

COLOR HAS TEMPERATURE

Color is warm or cool. Half of the color wheel is warm, the other half cool. This is important. In watercolor, sometimes we move rapidly, faster than we can intellec-tualize, then these things must come by instinct.

This is an application for your consideration.

SUN

Warm Influence

SKY

Cool Influence

Sketch a barn on watercolor paper. We will paint this applying the theory of a sunny day.

In the bucket we have the red paint with which the barn is painted, a Cadmium Red Medium. With the sun coming from the upper left and somewhat out in front of the barn, the front of the barn will be influenced by warm or yellow.

Mix Cadmium Red and New Gamboge or use a Vermillion on the front of the barn. For the side of the barn away from the sun, the blue sky will influence the side in shade somewhat and we will have Cadmium Red mixed with blue or use Alizarin Crimson. This also gives us a darker value to show change of direction. The shadow would be darker and colder than the side in shade. The side in shade would reflect a small amount of red into the blue, resulting in a purple shadow.

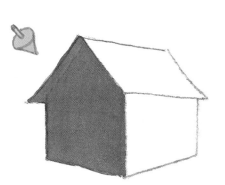

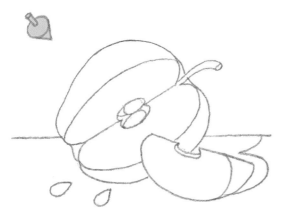

A LIMITED COLOR SCHEME

On a ¼ sheet, draw an apple with a section removed. Put an arrow in the upper left to remind you of the light source. From the color wheel, select a semi-triad color scheme. The apple is red so the complement is Thalo Green. A Cadmium Yellow Pale will simulate sunshine. Practice with these three to

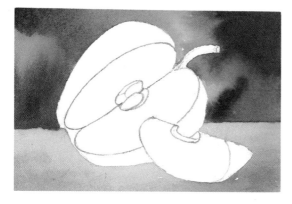

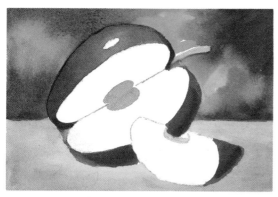

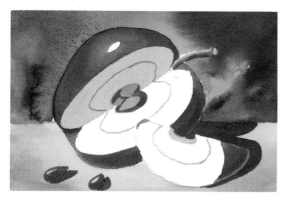

see what colors and greys you can achieve. Paint in the top shape, using all three colors very intense, cool against warm and warm against cool. Keep verigated or textured to make this contrast with the apple. Paint the lower section spotlighting it toward the center to draw the viewer in.

Paint around the highlight on the upper part of the apple adding yellow to the red. As you go away from the white, drop the yellow and use only red, then as it curves around and away, add green. On the bottom of the apple use red. Push back and cool with green. Paint the front of the apple section warm to cool. The area where the seeds appear is painted with a grey mixture of green and red. Add the shadow of the apple, section and seeds with a dark grey of green and red. Wash a light warm grey over the top half of the cut in the apple. The stem, seeds and lining are done in a mixture of all three colors.

COLOR HAS VALUE

Shown here is the relationship between a value painting (one color, Burnt Umber) and a color painting using Yellow Ochre, Burnt Sienna and Ultramarine Blue. First we make a sketch of shapes and decide on the whites.

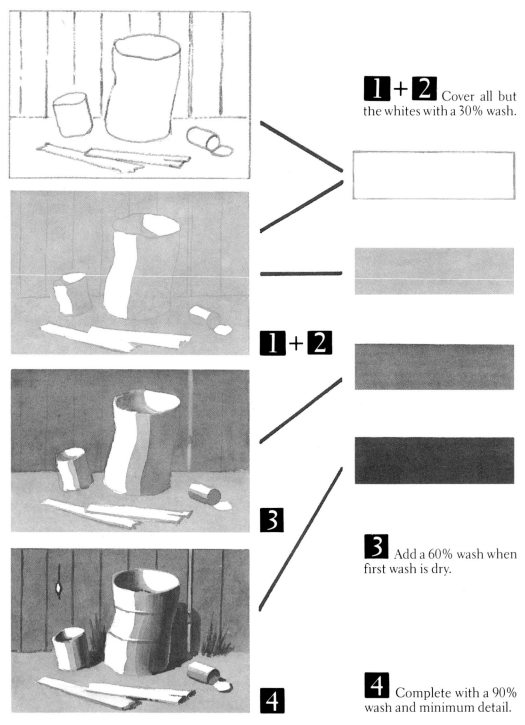

1 + **2** Cover all but the whites with a 30% wash.

1 + **2**

3 Add a 60% wash when first wash is dry.

3

4 Complete with a 90% wash and minimum detail.

4

Make a sketch and decide on the whites, then, what color, where?

Step (1) and (2): The color is your decision but in this painting, Yellow Ochre is used over the fence, on the container and the ground. Next add a little Burnt Sienna for local color on the cans. Charge in some blue on the shade side to get some cool next to the warm color, keeping it all as near to 30% as possible.

Step (3): Using stronger Burnt Sienna and blue to bring them up to 60%, everything is given shape, with consideration for warm and cool and value. This step is where the painting is "made".

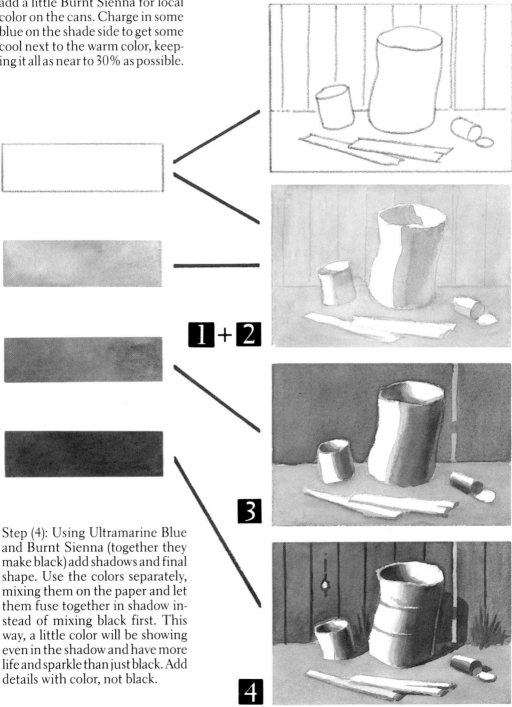

Step (4): Using Ultramarine Blue and Burnt Sienna (together they make black) add shadows and final shape. Use the colors separately, mixing them on the paper and let them fuse together in shadow instead of mixing black first. This way, a little color will be showing even in the shadow and have more life and sparkle than just black. Add details with color, not black.

COLOR IS EMOTIONAL

Color induces feeling. People respond to colors in many ways. Paint with this in mind. We feel blue, see red, are green with envy, etc. If a painting is to communicate, it must not only look like something, it must feel like something. The viewer should experience some of what the artist did. We never just look at something, we respond. Our vision, more than anything else, allows us to be impressed favorably or otherwise with the world we live in.

HAPPINESS, JOY, FUN, EXCITEMENT

High key, bright colors are used to denote activity, fun, pleasing sensations.

MYSTERIOUS, SOMBER, SAD, MOODY

In darkness colors are not easily distinguished by the eye. Things seem concealed, hidden or partially revealed. We can't see in the dark so we think of goblins, etc.

SOBER, SUBDUED, QUIET, CONSTRAINED, RESTFUL

Greys can induce many feelings; warm and pleasant, cool and uncomfortable. A wondering what will happen next. Contentment.

GREENS OF SPRING

HEAT OF THE DESERT

COLD OF WINTER

38

This painting was done on the northwest coast on a foggy morning. There is calm and a sense of mystery. Anticipation... Is it going to clear or rain? A little activity around the boat is intriging.

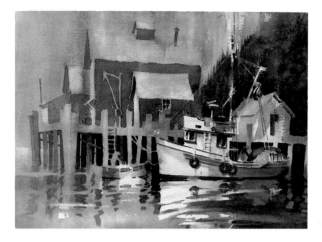

A painting done in Old Town, San Diego, on a clear sunny day. Bright, alive, inviting, a pleasant place and time. A lovely place to visit attitude.

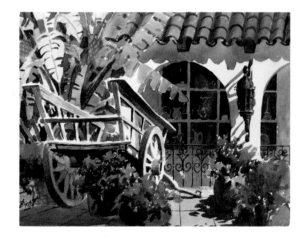

Painting on location in the high country is good for mood. This was painted in a motel after a cold walk in the High Sierras. The warms are just what you see but not enough to keep you from freezing.

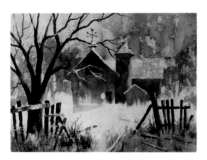

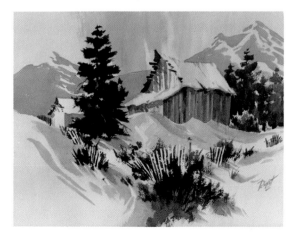

In the morning, in the midwest, a mist forms on the ground and disappears with the sun. This mystery of morning was painted in Wisconsin.

THE STAGE

In my studio, I have a model of a stage to remind me that I am a stage manager and a production manager. I am working on a flat surface but I want to give the impression it is a box with light and air. The back props and wings are first consideration in painting. In drawing, it is exactly opposite; we draw the actors (objects) and then stage them. In painting, we prepare the stage and then put the actors on the stage lighting them in order of importance. The spotlight is always on those on whom we want to focus attention, the high paid actors. A box 12″ × 12″ × 16″ wide, open in front is about right. It will help you to build this model. Keep it in your studio. In basic landscape, we want to curve the surface. To have sky overhead, go back to the horizon and have the foreground come forward, so we can walk into the picture. Paint a warm blue at top (Ultramarine Blue), add yellow moving toward a cool green on the horizon. Beginning with Yellow Ochre at the horizon with a little blue to grey it, come forward or down adding Burnt Sienna and dropping most of the blue. In the foreground, we have a strong (intense) mixture of Yellow Ochre and Burnt Sienna. A mountain range is added with a purple to keep it back on the horizon. A green tree is added in the middle ground. Add a barn in front of the tree. Next glue some posts standing in the foreground. This plan of the stage indicates that you can walk into the stage and around the objects. Think about this when planning and painting.

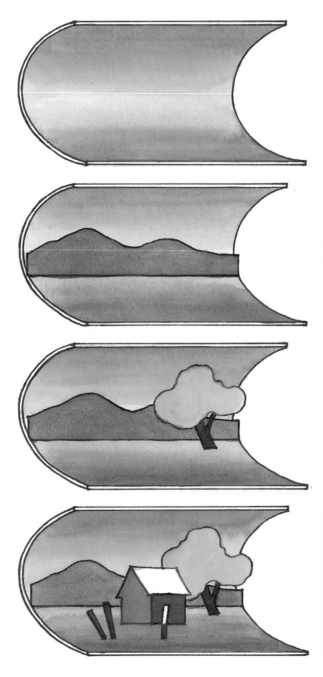

AERIAL PERSPECTIVE

Values give a feeling of depth. Strong or intense color in foreground, soft pastel in background. Warm colors come forward. Cool colors recede. The last color on the horizon is blue. Intense color and detail come forward. Do some small practice paintings. Visit museums and libraries. Darks push back. Whites come forward.

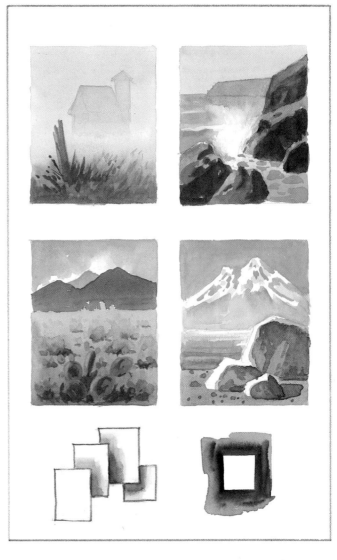

Do a ¼" practice painting based on preparing the stage and putting actors on the stage. Landscapes are read from the bottom up. The viewer needs to feel invited in. He or she needs to be able to get across the foreground. Notice the posts are dark against the light and light where they enter or are against dark. Nature transposes values like this. Look for it.

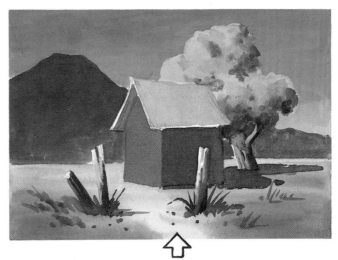

41

TECHNIQUE

There are many ways to paint a watercolor. Try many ways. Discover those that work best for you.

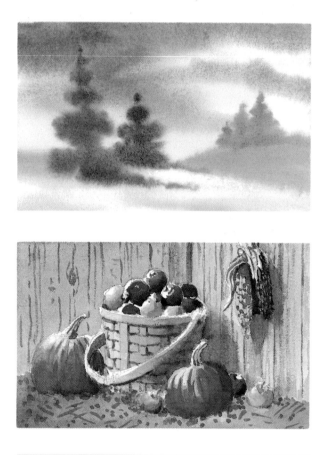

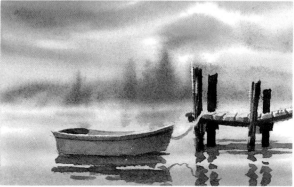

Paint, experiment, remember what happens. You will develop your own way. Continue to reach out. If you worry about creativity, technique will come. If you worry about technique, creativity will never come.

WET INTO WET

How wet? Use the sponge to wet the paper. Go over it several times with clean water. Wring out the sponge the last time over. The paper should not be sloppy wet, but thoroughly saturated. Some artists wet both sides. The pigment in the brush should not be too wet because there is already water in the paper. All edges will be soft but you can maintain some control if you don't work too wet. Experiment!

DRY BRUSH

A more careful drawing is required here. Each area is painted in with an attempt to relate it to everything else. Much detail and texture are possible.

COMBINATION

This is probably the most popular way to work. Start with wet into wet for soft large shapes. Define some intermediate and smaller shapes as the paper begins to dry. After the paper is dry, the painting is completed by defining small shapes and adding detail.

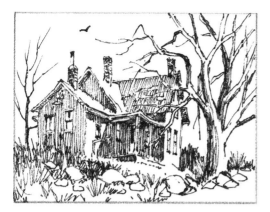 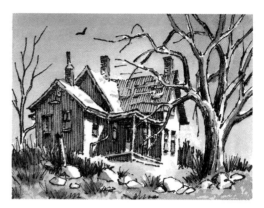

PEN, INK AND WATERCOLOR WASH

There are two ways to do this. In the one shown here, a pencil sketch is made first. Next, the sketch is inked with a waterproof pen leaving some areas open so the viewer can get in and out of objects. The water-color wash is done over the pen and ink drawing. An equally popular method is to do the watercolor wash first, very freely, then sketch with waterproof ink over the wash when dry, defining only what is necessary and pleasing. See page 63.

 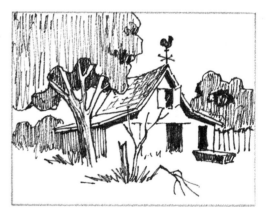

ABSTRACT FIRST (FORM TO CONTENT)

An abstract arrangement of color setting the mood and leaving some interesting whites is washed on a sheet.

A drawing made at another time or in the future which seems to further this mood or belong to it is sketched lightly over the painting. Only those values and colors needed to coax out the subject (content) should be used. Add detail judiciously, and a special painting is completed. See page 61.

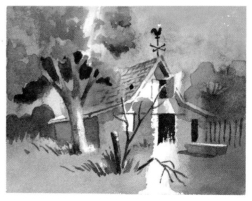

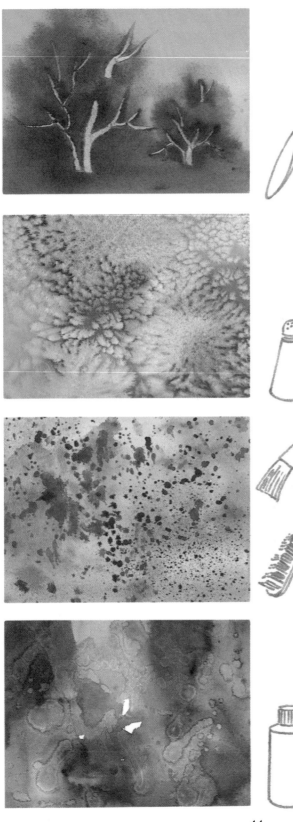

SCRAPING

Practice by washing an indication of trees and bushes on watercolor paper. Using the wedge end of the brush squeegee the paint out of the way. Make a single stroke from wide to narrow by manipulating the brush. Straight up for finer lines, more horizontal for wide strokes. The paint must be wet but not too wet. Practice!

SALT

A random texture like this may be ideal sometimes. Learn to do it. Wash several colors in varying intensity on watercolor paper. Sprinkle salt in while color is wet. Let dry completely and brush salt off.

SPATTER

Charging a brush such as a 1″ or ½″ or a large round and striking it against the finger just above the painting will produce spatter in a given area. Also experiment by putting color in a tooth brush and running your thumb over it aimed at a given area. Protect other areas with newspaper or cardboard.

ALCOHOL

Watercolor is repelled by the alcohol. Dropped into a wet wash, it will do exciting things and make unusual shapes. This works best on smoother papers. Experiment!

SPONGE

Many painters use an assortment of sponges for different textures. Mix several colors separately on the palette so you can pick up one color or several with a sponge. Apply it to painting over dry washes or wet. Experiment!

SANDPAPER

Used in many ways to reduce a value or to give texture. It works well on rough paper for textures. Try it on the light side of a tree or bush for added sparkle.

MASKING

Use an old brush for this and clean it out immediately afterwards. Applying masking fluid only to dry surfaces painted or unpainted. Let it dry thoroughly before you paint over it. Remove it with your finger or a rubber cement pick up only when paint is dry.

SCRATCHING OR ERASING

This can only be done when painting is dry. Fine lines like wires and poles can be scratched out with a knife or razor blade. An eraser can be used for reducing a value or reclaiming some whites. For hard edges, use a piece of stiff paper. For poles etc., hold two pieces of plastic or paper on each side and erase between them. Shapes can be cut out of plastic sheet and the plastic held down and erased. A damp sponge or paper towel wiped over the shape in the plastic will pick up the pigment on the painting, leaving a white or light area.

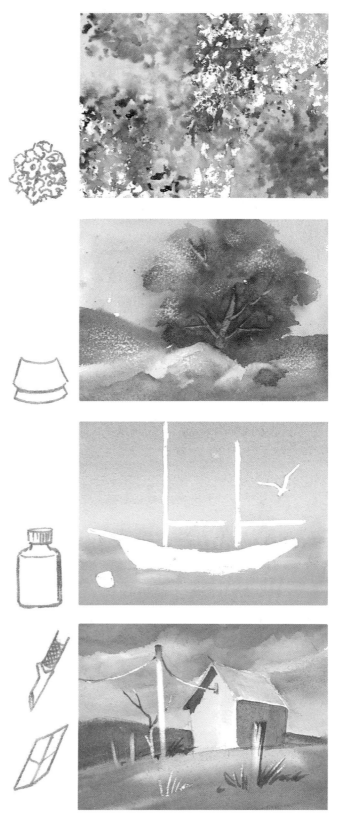

DEMONSTRATIONS

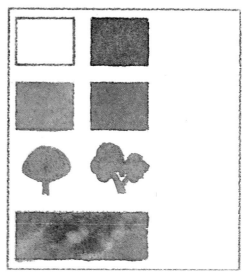

Things to think about while painting: Is it too light or too dark? Is it too warm or too cold? Am I happy with these shapes as drawn or should I change them now? Am I balancing color around the sheet?

Step back and analyze often as you paint. Nothing is as important as what is happening on this piece of paper.

Sketch these shapes on a ½ sheet until you feel good about the arrangement of the whole area. Now what are you going to say? Good day, cold day, rainy day, sunshine, etc. This will help you determine your color scheme. Here, we are painting a warm, fall day with a limited palette, Burnt Sienna and Ultramarine Blue.

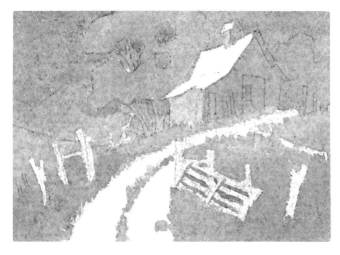

Thin out some blue on the cold side of your palette and some Burnt Sienna on the warm side. Lay an approximate 30% wash over the entire sheet except whites. As you move along, change colors but not values. Think in terms of warm and cool, local color and source of light. SAVE THE WHITES. This is essentially a high key painting at this point.

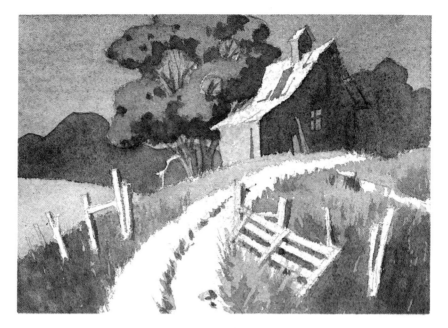

3 Just how long to wait before continuing will be the result of experimenting. Intensify colors (60%) and make changes at this point. Establishing value contrast (shapes) and warms against cools is important at this time. Most paintings fail because not enough time is spent at this stage.

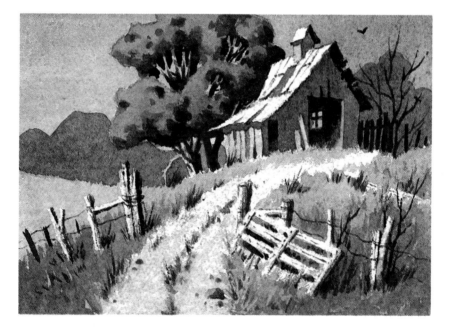

4 Final shapes are completed at this time but not with black, with intense color. Detailing can be done after painting is dry or almost dry. Over detailing is called "tickling it to death". Be selective and use restraint. Use color for punch, not black.

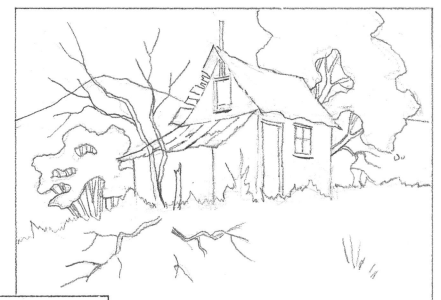

First sketch this mountain cabin with emphasis on large shapes. Be sure the pencil is dark enough to see through several washes but not so dark that you can't change shapes as you paint. Things look different when you begin to add color. Stay flexible. Learn to enjoy the media. This color scheme is Yellow Ochre, Burnt Sienna and Ultramarine Blue.

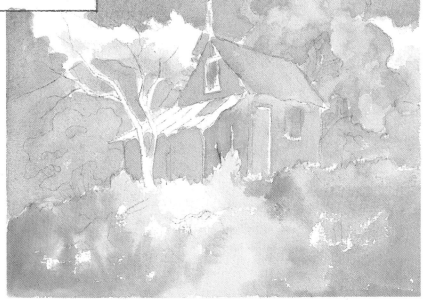

1 + **2** Begin with a dry sheet. Paint in 30% wash, observing local color in some areas. Be conscious of warm against cool and cool against warm. Let it happen on the paper, not in your mind. This first wash is in essence a high key painting.

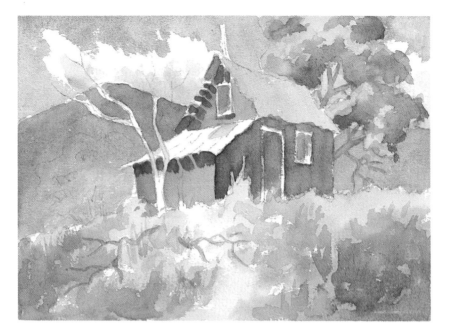

3 Follow through with stronger, more defined shapes. Keep the more defined areas toward the inside or central area of the painting. Overall, you should be working in about 60% value.

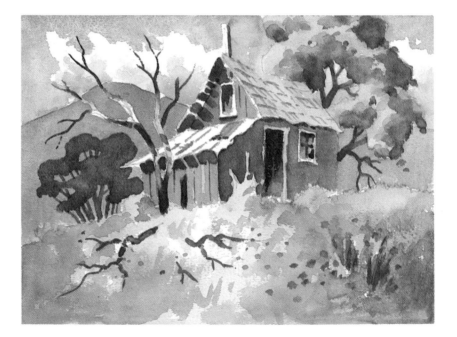

4 With a 90% value, you can push things back, around, overemphasize shade and shadow and bring those things into focus that are the actors on the stage. Consider last minute details carefully. Don't go back into the painting until you have matted it and definitely decided what your are going to do.

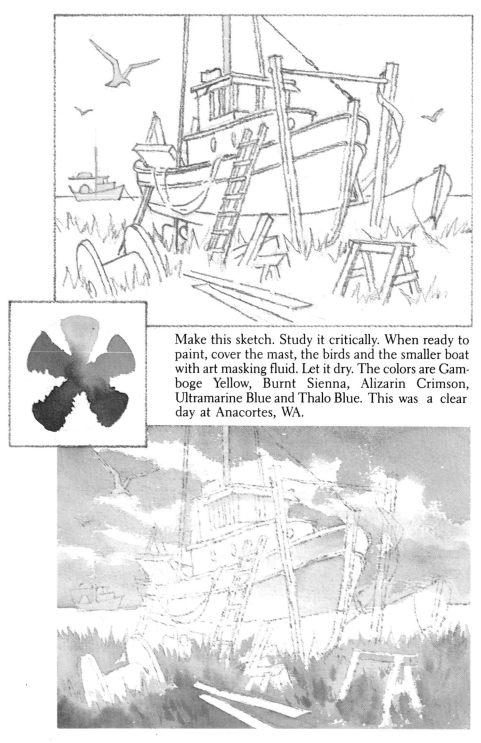

Make this sketch. Study it critically. When ready to paint, cover the mast, the birds and the smaller boat with art masking fluid. Let it dry. The colors are Gamboge Yellow, Burnt Sienna, Alizarin Crimson, Ultramarine Blue and Thalo Blue. This was a clear day at Anacortes, WA.

1 + 2 The general feel of the painting is washed in all at once with the 30% wash. More than enough whites are left to be delt with later. Warm blue sky overhead, warm foreground at our feet.

50

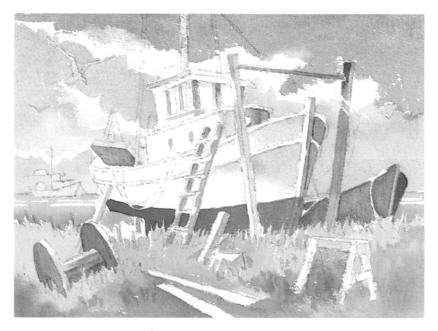

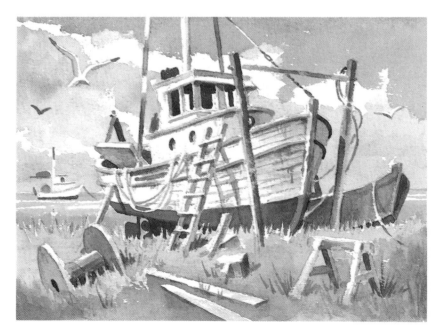

3 Our 60% allows us to work transparent and still consider all shapes. Colors can be changed here and final adjustments made around the painting, especially if the original wash is still wet. Steps 2 and 3 are our experimental, searching stages. The painting is discovered here. It has not yet been "nailed down".

4 Let step 3 dry and remove the art masking fluid, rubbing it with your finger. Use color in finalizing shapes. Put in shadows, then complete by detailing only what you feel is important. Final stages are executed with 90% value.

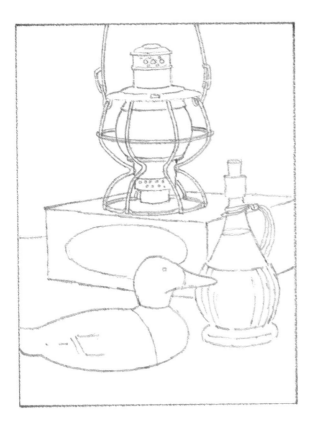

These studio props are just a suggestion of the many things you may have available for a still life. This is a vertical ½ sheet 15″×22″. After the sketch is complete, consider a light source, in this case upper left. The colors used are Analogous with the exception of Cobalt Blue. Yellow Ochre, Burnt Sienna, Burnt Umber, Alizarin Crimson.

1 + **2**

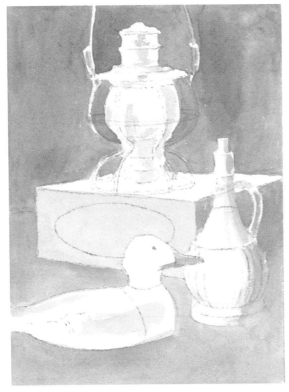

With a wash of Yellow Ochre and Burnt Sienna approximately 30% value cover all but the whites. More than enough whites have been left for detail and clean colors in certain areas.

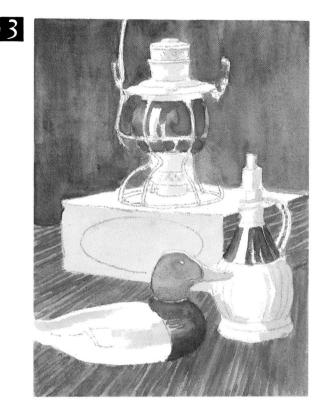

3

Burnt Umber and Blue are for this next step. They give a dark value and are used for a verigated background and wood grain in the floor. Alizarin Crimson with blue for darks are used in lantern globe. Yellow Ochre and Blue for the green in ducks head.

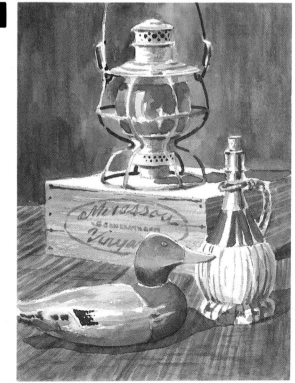

4

The finished painting receives final shapes and details with intense color. Almost pure blue is used for shadows. Mat the painting with a trial mat. Stand back 8' to 10'. Put in only the details that will show from this distance.

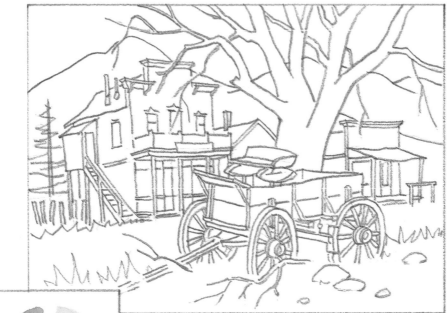

On a ½ sheet, sketch the big shapes and any detail you feel necessary. As you progress, you will require less drawing with the pencil as you will become more competent with the brush. The light is coming from the upper right. The colors used are New Camboge, Raw Sienna, Vermillion, Alizarin Crimson, Ultramarine Blue and Thalo Blue.

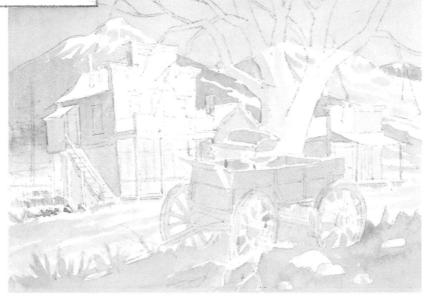

1 + 2 Paint first wash with mood in mind...cold, deserted, abandoned. This is more important than local color. Wash in a cool green winter sky. Fall colors are used in the foreground. Save the whites. Practice painting around whites every day.

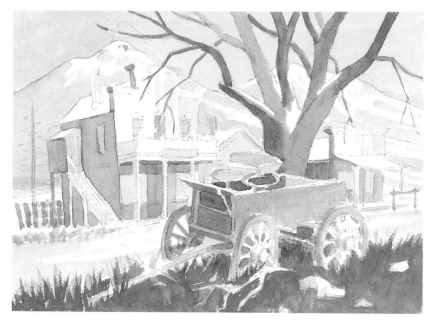

3 Be concerned with shapes. Also warm against cool. When painting a tree, remember all the limbs are boring if they are all the same color. Push back some limbs with dark color and bring some forward with warm colors. Trees have three dimensions.

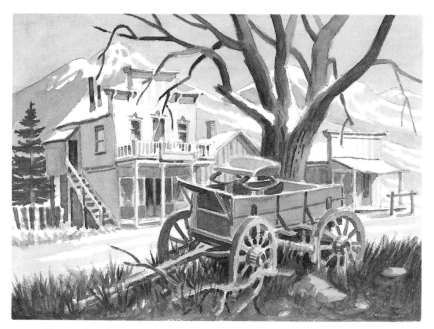

4 Paint the foreground in shadow so we will look past it and see the whitest whites and detail in the old hotel on the left. When I think a painting is about 90% finished, I put a trial mat on it and look at it for a day or two before deciding what to do, if anything, to finish it.

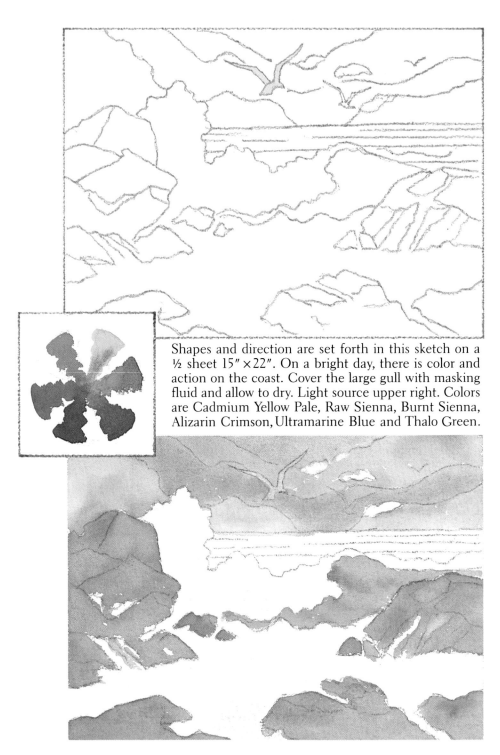

Shapes and direction are set forth in this sketch on a ½ sheet 15″ × 22″. On a bright day, there is color and action on the coast. Cover the large gull with masking fluid and allow to dry. Light source upper right. Colors are Cadmium Yellow Pale, Raw Sienna, Burnt Sienna, Alizarin Crimson, Ultramarine Blue and Thalo Green.

1 + **2** More than enough whites have been saved on the first wash. The mood is pretty well set. The color chord or overall feeling is established in the beginning with local color being secondary.

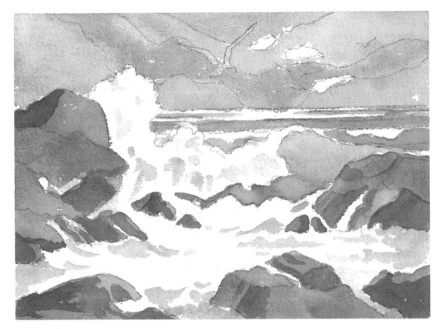

3 Light source and shape become important at this time. Add value in the sky and foreground, using more pigment and less water and painting color over color, not necessarily the same color. Add new color to each shape. Paint in the ocean and the foreground.

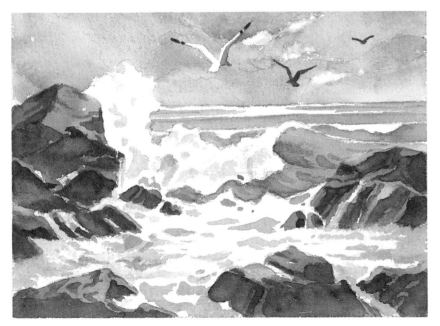

4 Remove the art masking fluid and add final detail to the birds. Don't overdo the water. If it gives the impression of water from a distance of 8' to 10' that's all that's necessary. Give the rocks final form so they feel solid against the sea. PAINT! PAINT! PAINT!

GALLERY

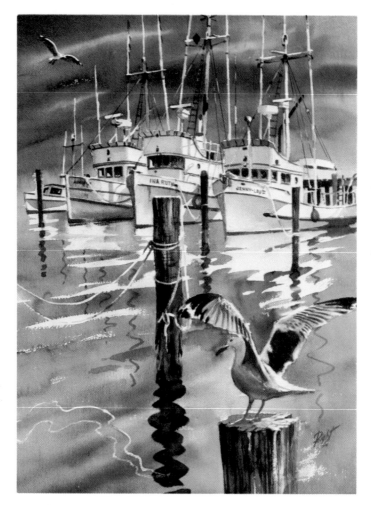

Looking to the Sea
22" × 30"

This painting was begun at San Diego's Fisherman's Wharf and completed in the studio. A masking material was used for the masts on the boats.

Apple Pie Anyone
18" × 24"

This painting was completed after a midwest workshop. I spotted this old pump on the back porch of a farmhouse and added the apples. The sketch was made on location and the final painting in the studio in California.

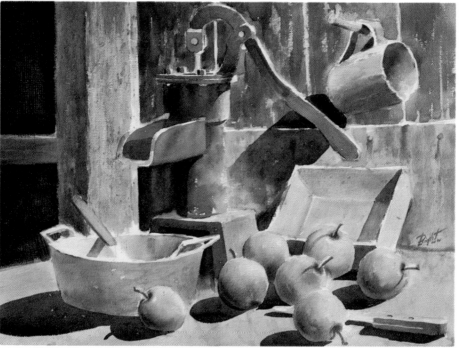

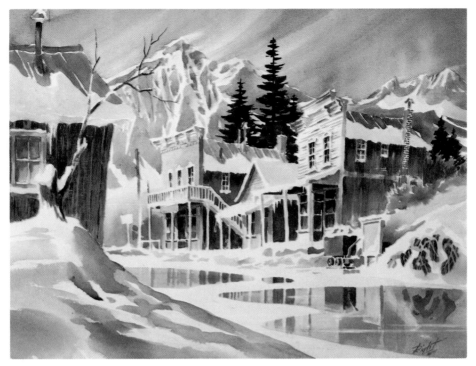

Dead of Winter 22″ × 30″ Georgianna Lewis Collection

Inspired by a trip to Colorado High Country in the winter, the painting was done entirely in the studio from sketches and photographs.

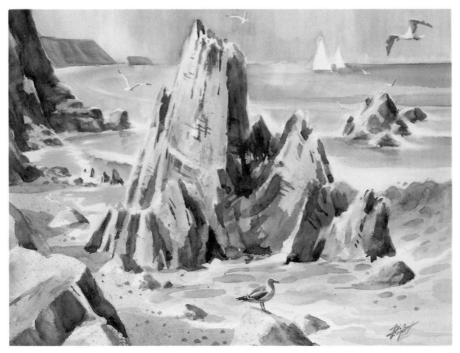

Timeless Encounter 18″ × 24″ Private Collection

Painted in Corona del Mar on location. The rocks, the sea, the boats and gulls remind us that we are all involved in the eternal struggle.

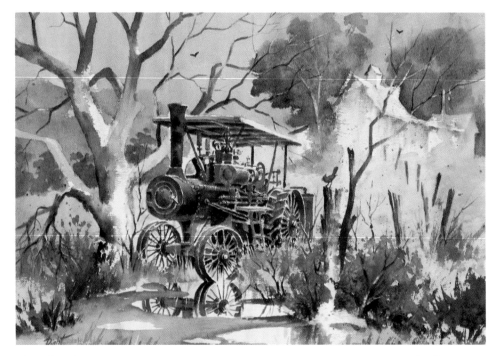

Cardinal Opinion 22″ × 30″ Artist's Collection

This began with an abstract color background. Some sketches made in Mount Pleasant, Iowa seemed to work. Minimum detail except the steam tractor and bird.

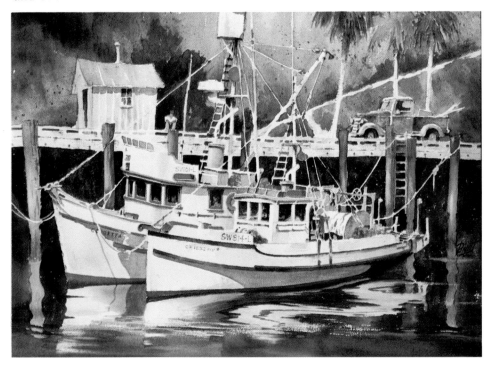

San Pedro Partner's 22″ × 30″ Artist's Collection

These two boats seem inseparable. Every workshop at San Pedro, there they were, riding the tide. With a little observation, we become aware of the full partnership, man, pick up truck, boats, land and sea.

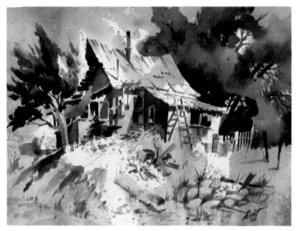

Valley Center Fixer Upper

18″ × 24″

This limited palette abstract was painted long before an exciting 18″ × 24″ pen and ink was made in Valley Center, CA. They seemed destined for each other. The painting was imposed over the abstract using the same palette.

The Midwest Story

11″ × 15″

Mari Calixto Collection

Painting a background first and letting it dry, then coaxing realism from it is a rewarding challenge. This Illinios barn and windmill were good subject matter.

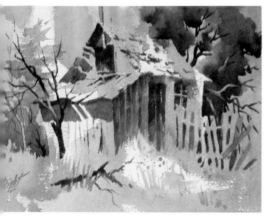

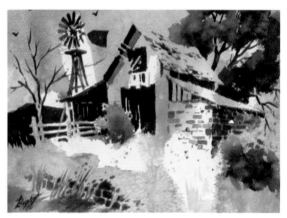

Play of Light

11″ × 15″

Mari Calixto Collection

Ths little shed was painted over a background on location in Nebraska. It had good feeling of light pouring over everything.

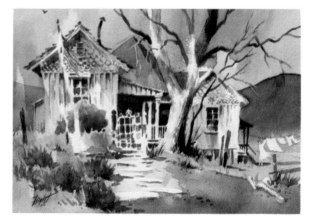

Judy's Place

15″ × 22″

Painted high in the Ramona Hills, this old school house was being lived in by a very colorful old lady, a writer and a rancher. The background was painted first.

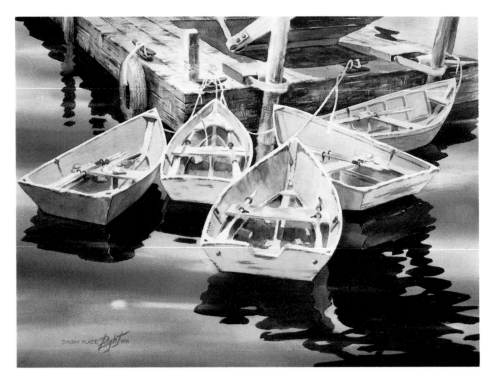

Dinghy Place

22″ × 30″

Dr. Frank Goldsmith Collection

The sketches for this painting were done under a dock at Santa Barbara, California. Painting was completed in the studio on a full sheet 22″ × 30″.

New England Assortment

Vertical 15″ × 22″

These items were brought back from the East Coast and used for a still life demo on a drawing/painting workshop. Still life paintings are challenging and need thought and planning to be "different".

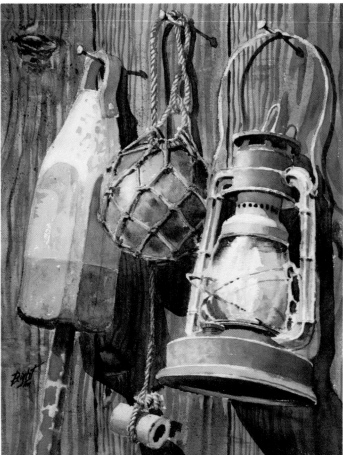

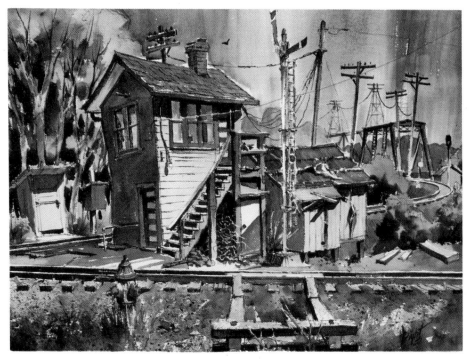

Louisiana Crossover 18″ × 24″

Drawn on location with a Sharpie pen on D'Arches rough watercolor paper. It was then washed in with a full palette. This was a demonstration for a Missouri workshop completed on location.

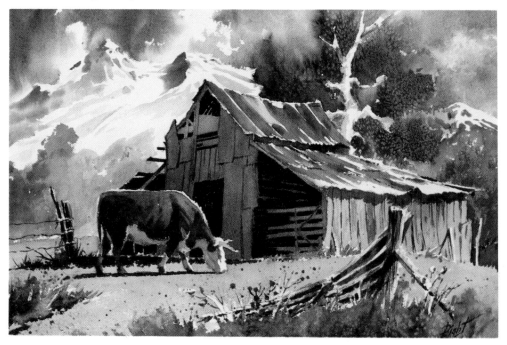

High Country Lunch 15″ × 22″ Russell Duncan Collection

This Wyoming steer is enjoying the last of the grass. There is snow in the mountains and fall is coming on. Old Western ranches offer unlimited possibilities.

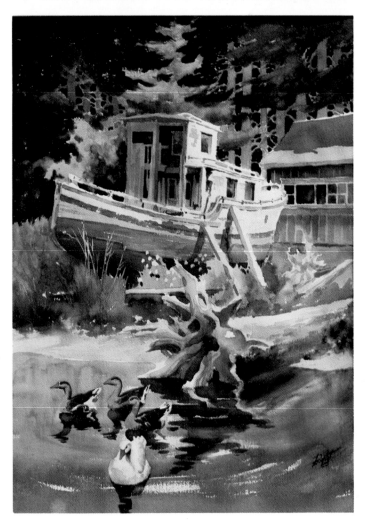

Seafarers...Old and New

Vertical 22" × 30"

Charlie Plotner Collection

This painting was completed in a motel room at Friday Harbor on San Juan Island after sketching all day at Rouche Harbor at the other end of the Island. Some Polaroid shots were made for color notes.

Colorado Winter

18" × 24"

Dr. Douglas Moir Collection

Painted from sketches and photos taken just west of Alamosa, Colorado. Paint as soon after sketching as you can if you can't work on location. It is important for the feeling and the mood to be fresh in your mind.

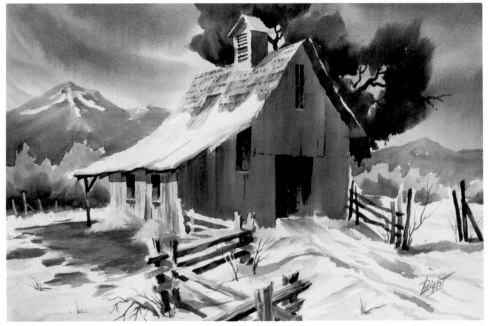